Dot-to-Dot Book For Kids Ages 4-8

This Dot to Dot Book For Kids Belongs to:

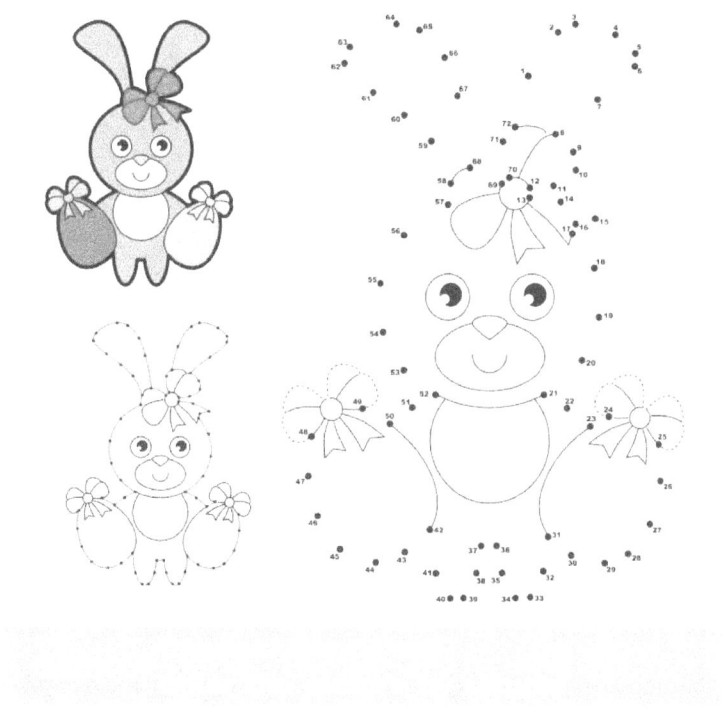

Copyright © 2019 Easter Puzzle Books

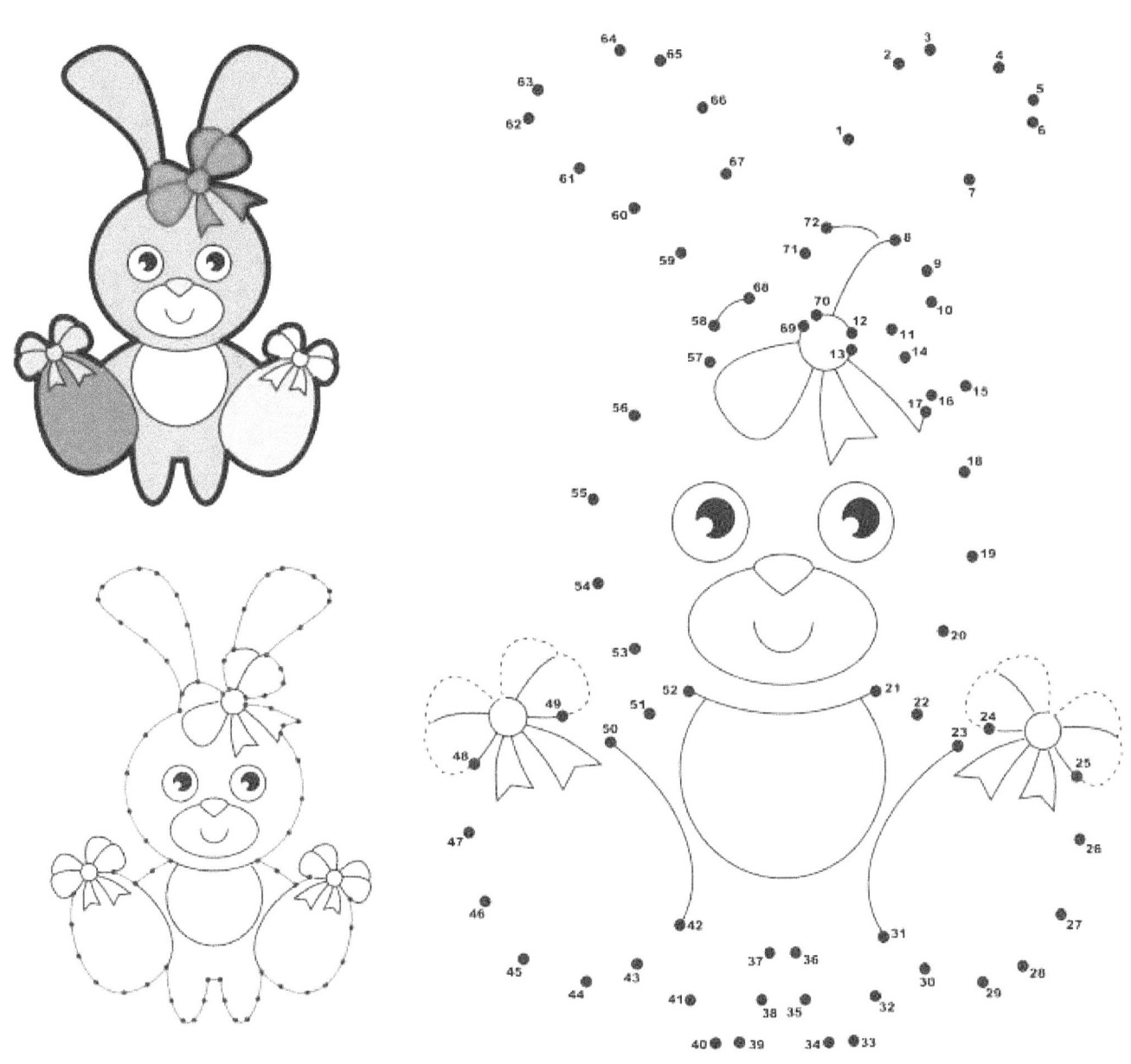

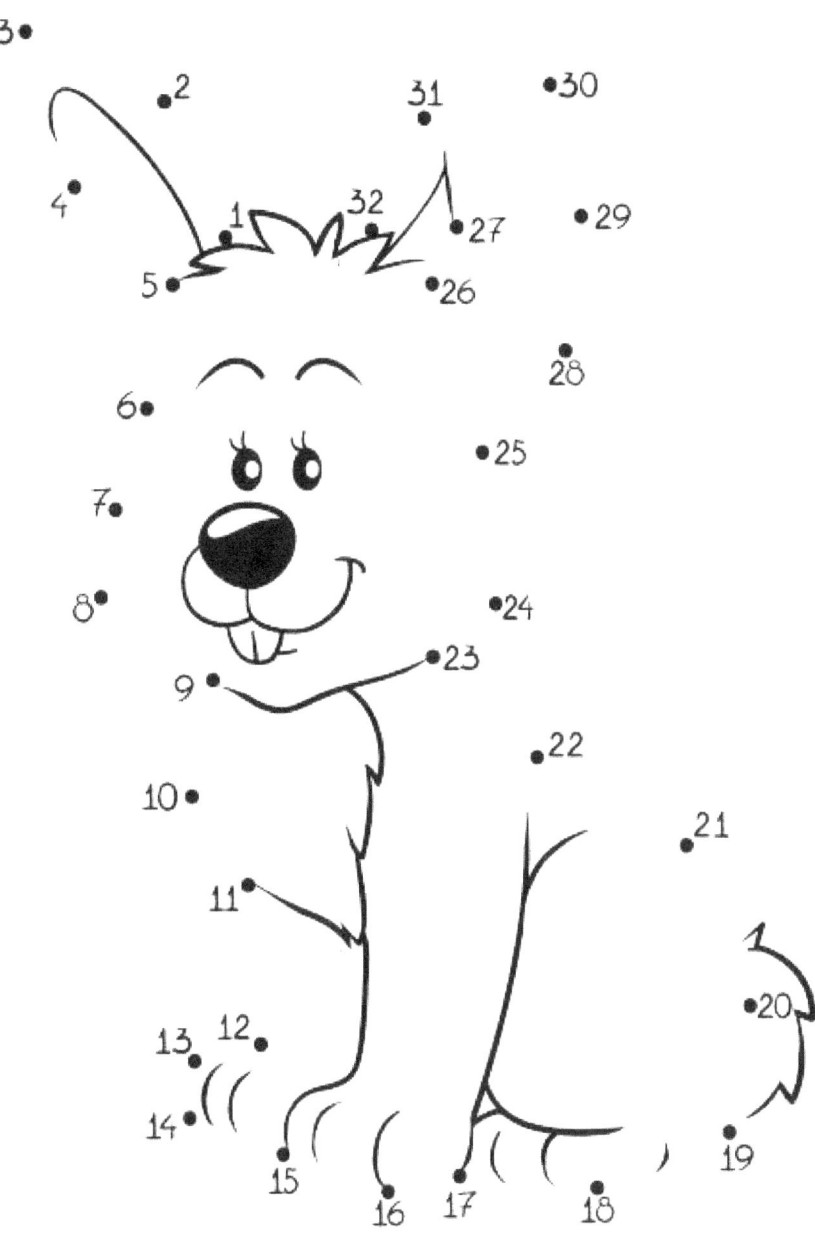
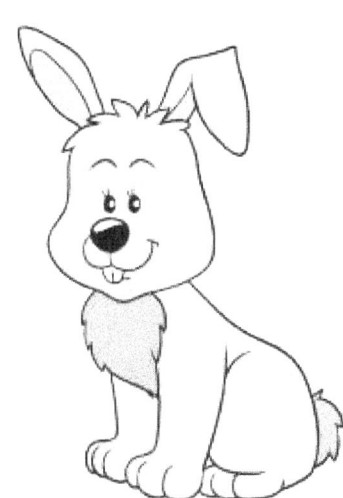

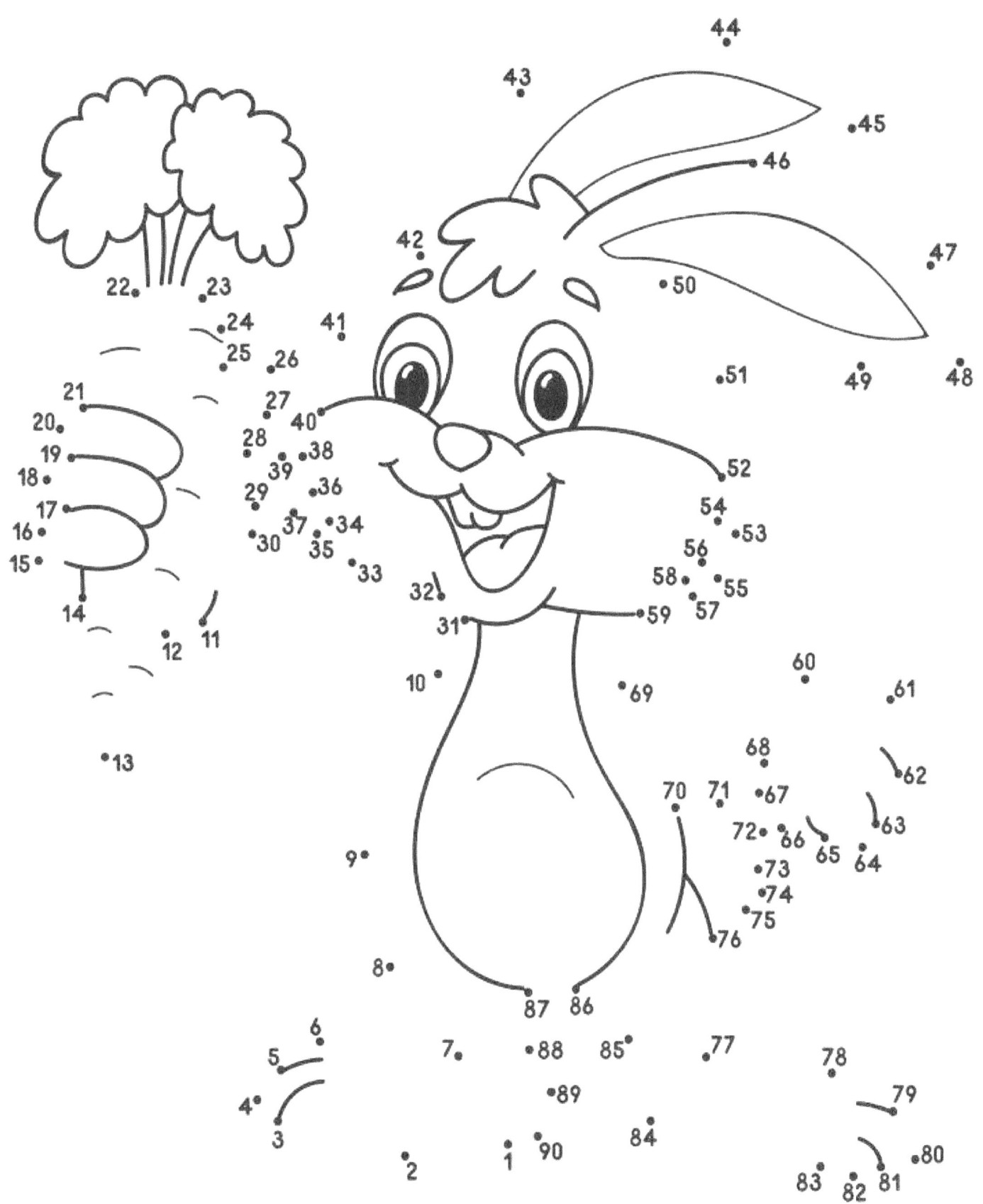

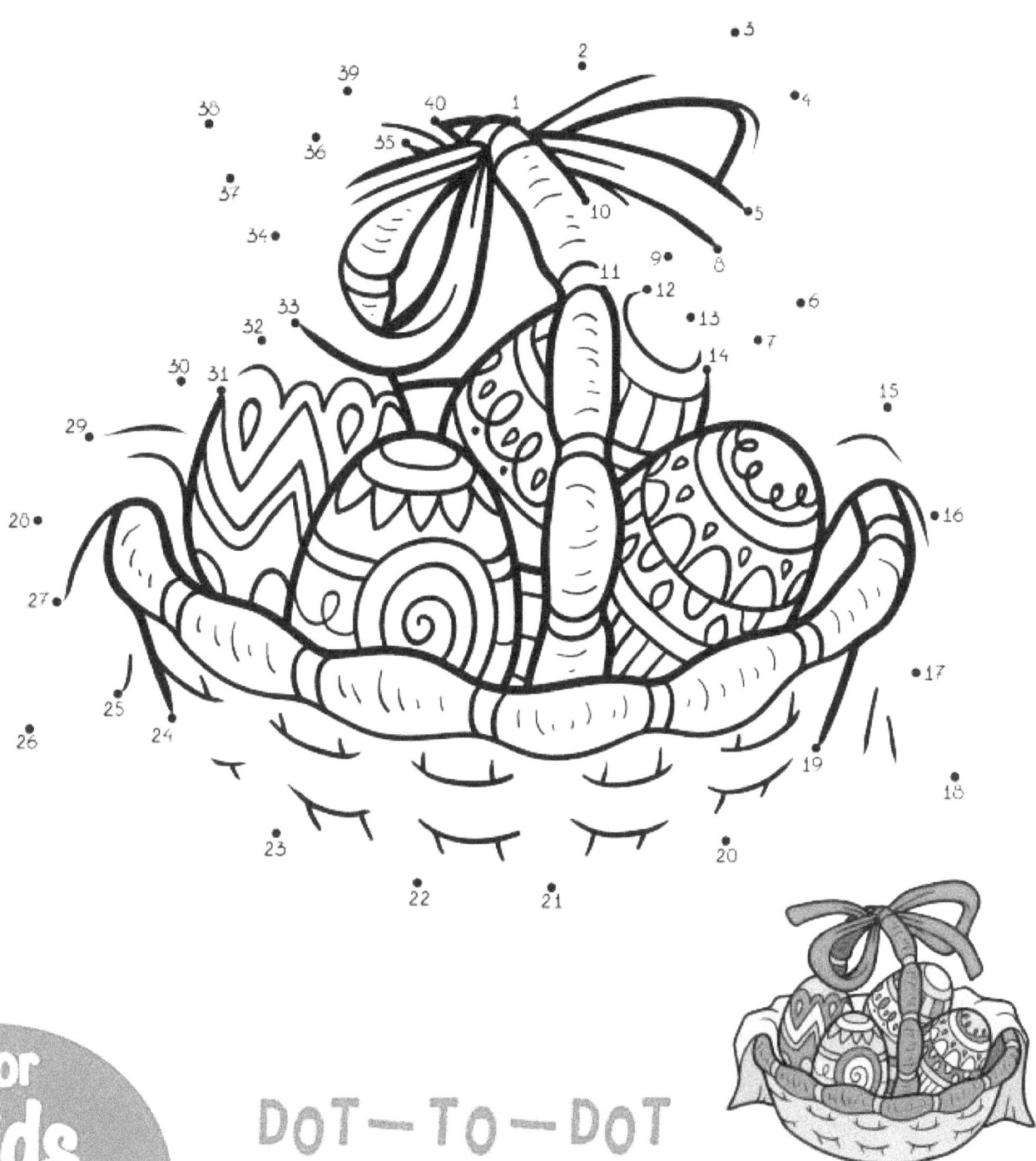

DOT—TO—DOT

for kids

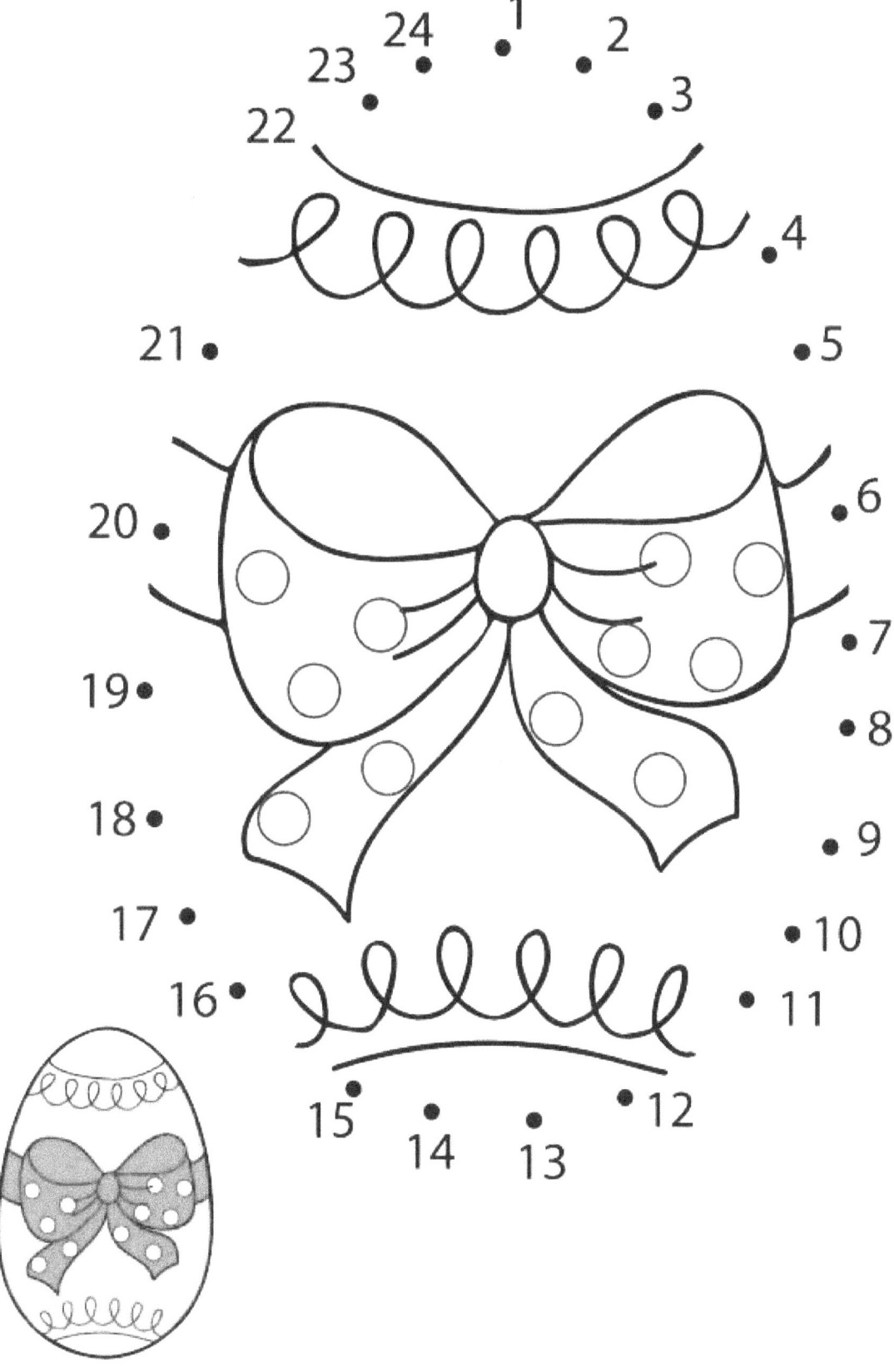

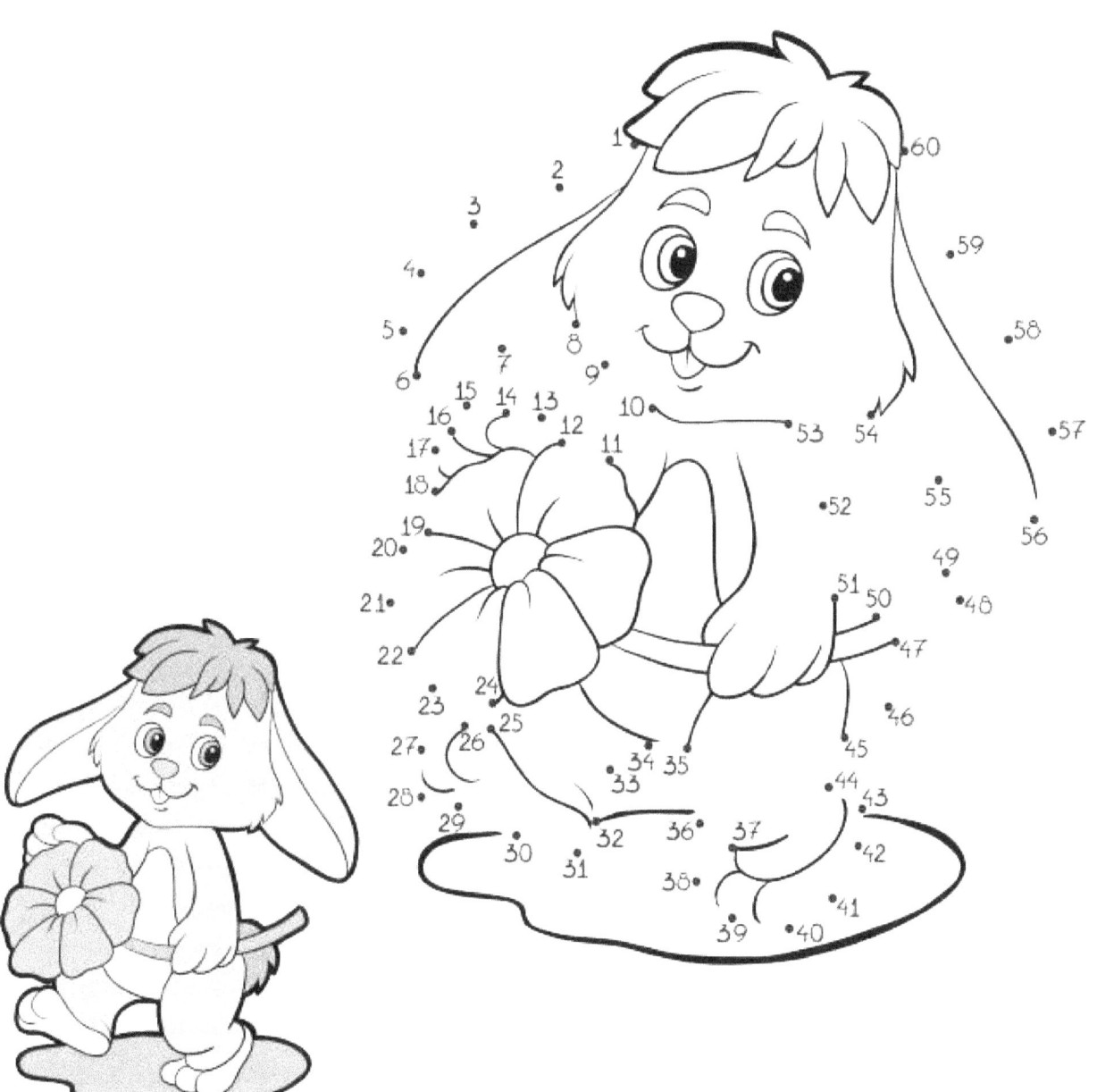

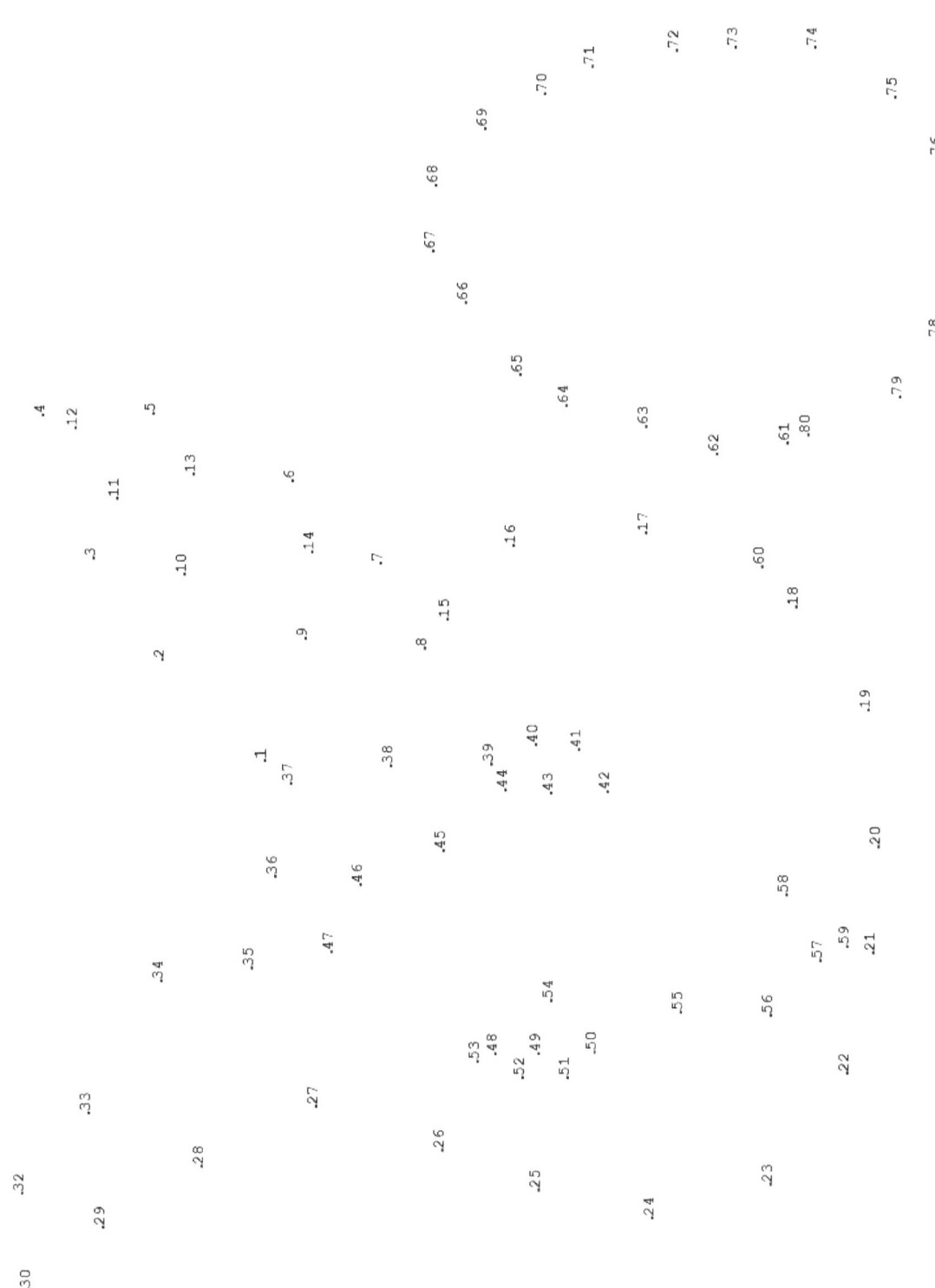

SURPRISE BONUS EASTER COLORING PAGES

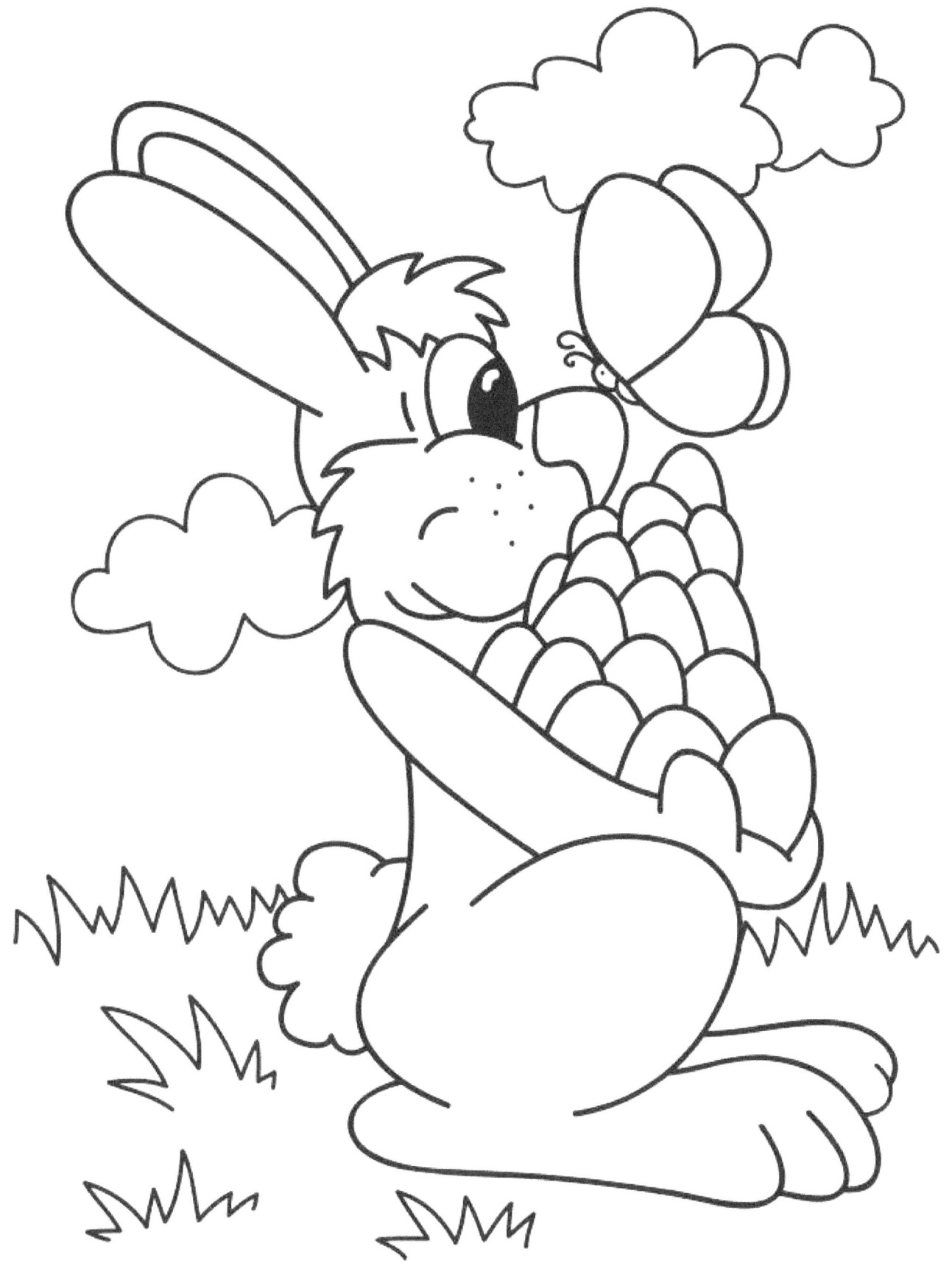

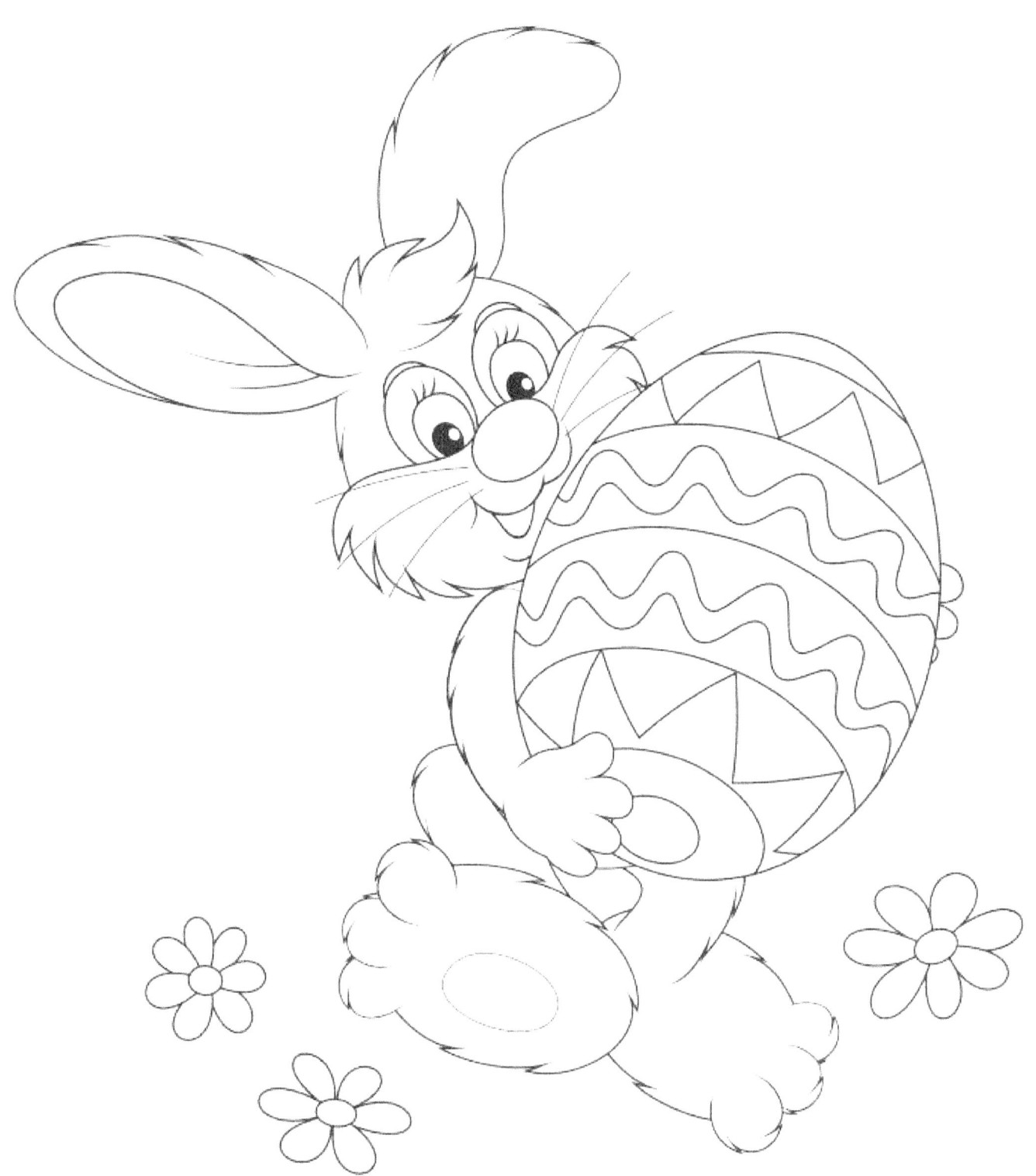